Flower jewelry p. 14

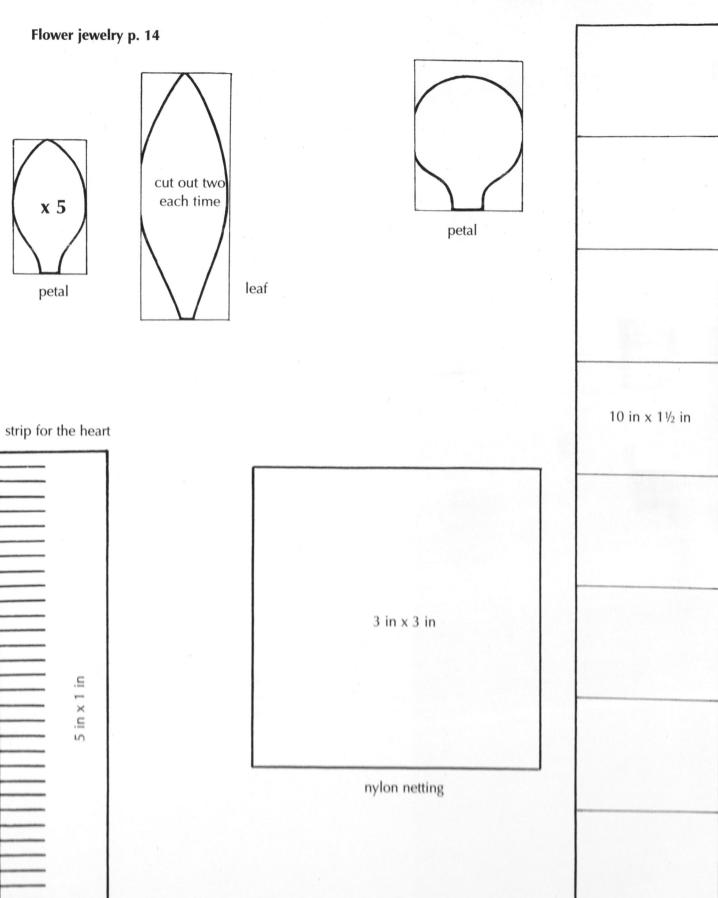

x 5

petal

cut out two
each time

leaf

petal

strip for the heart

5 in x 1 in

3 in x 3 in

nylon netting

10 in x 1½ in

strip for the petals

Photography by Dominique Farantos

© of the american edition:
Editions Fleurus, Paris, 1997
ISBN: 0-7651-9103-2
© Editions Fleurus, Paris, 1996 for the original edition
Title of the french edition:
Kit Mercredi des Petits, Fleurs en papier crépon
English translation by Translate-A-Book, a division of
Transedition Limited, Oxford, England.
Printed in France
Distributor in the USA: SMITHMARK Publishers Inc.
115 west 18th street, New York, NY 10011.
Distributor in Canada: Prologue Inc.
1650 Bd Lionel Bertrand, Boisbriand, Québec J7H4N7.

Craft Kit

CREPE PAPER
FLOWER GARDEN

Marie Chevalier

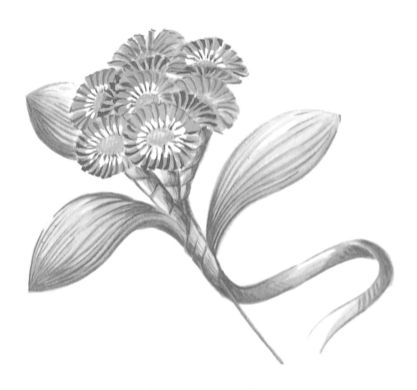

Illustrator: Véronique Marchand

SOME USEFUL TIPS

As the seasons change, we enjoy a wonderful range of different blooms in our gardens. This book will help you to create a flower-filled, colorful world all year round using crepe paper. The results will surprise you, your family and friends.

You will find the **templates** for the flowers at the beginning and end of the book. To make your templates, trace the outlines, copy them onto thin cardboard and cut them out. Write the name and part of the flower on each one (e.g. pansy petal, crocus leaf) and keep them in good condition.

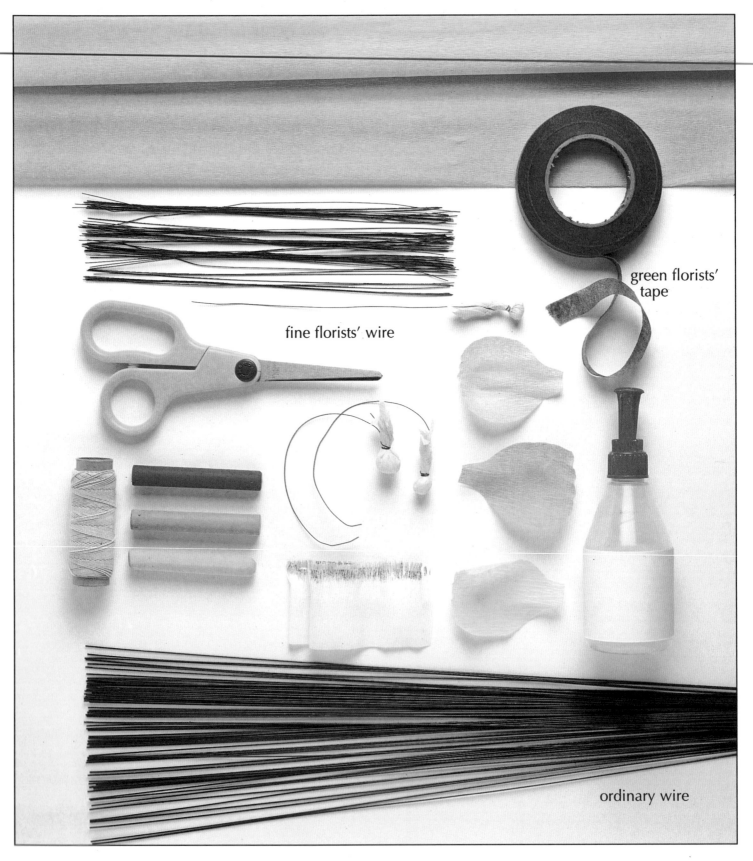

green florists' tape

fine florists' wire

ordinary wire

Materials

You should be able to buy the materials you need in craft shops, stationery departments and garden centers.

You will need:

• Good quality, colorful crepe paper.

• A pair of sharp scissors.

• A paper glue that won't leave marks – preferably liquid.

• Pastel crayons or felt-tip pens to color the paper.

• Fine florists' wire. You can buy it either pre-cut or in rolls.

• You can use ordinary wire if you want to make a longer, stronger stem.

• Ask an adult to help you cut the wire. It is best to use pliers, but an old pair of scissors could be used, although it is much more difficult.

• Strong sewing thread.

• Florists' green transparent tape to cover the stems. Unroll it carefully and wrap it diagonally around the wire. If you don't have tape, you could glue green crepe paper around the stems instead.

• Reindeer moss to display your creations.

Crepe-paper techniques

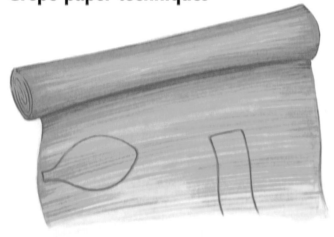

Unroll the crepe paper and draw around your templates. It is very important to always cut out the pieces in the same direction as the wrinkles in the paper.

Shaping petals

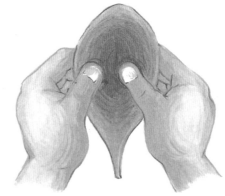

Hold the petal between the finger and thumb of each hand and hollow it out with your thumbs.

Fringes

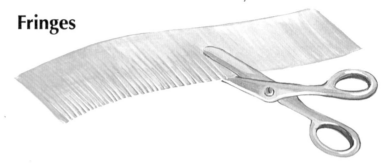

Use sharp scissors to cut very fine fringes in the edge of the paper.

Making leaves

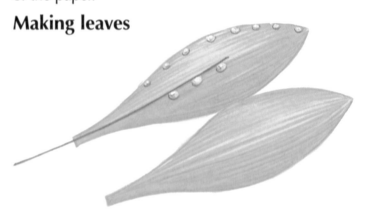

A leaf will look better if you make it with a double layer of paper. Place some florists' wire in the center of one piece. Put some glue along the wire and around the edge, then stick the second piece on top.

Stems

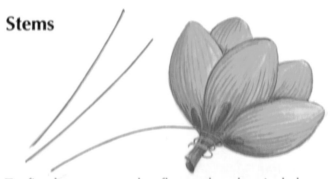

To fix the stem to the flower head, wind the wire once or twice around the base of the flower. The end of the wire can hang loose, ready to be covered with the green florists' tape.

Daisies

You will need: white, yellow and green crepe paper • pink pastel crayon • florists' wire • cotton wool • glue • templates (from the front of the book) • scissors • a basket • reindeer moss • green florists' tape • ruler

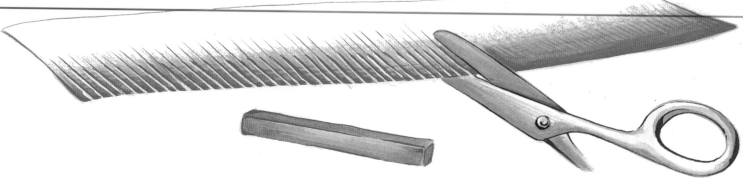

1 For each flower, cut out a strip of white crepe paper measuring 1¼ in x 8 in. Color in along one edge of the paper with the pink crayon, to a depth of about ½ in. Then cut a fine fringe along the length of the colored edge, as shown above.

2 To make the heart of the flowers, cut a square of yellow crepe paper measuring 1½ in x 1½ in. Make a little hollow in the center of the paper and insert a pea-sized ball of cotton wool. Tie with florists' wire.

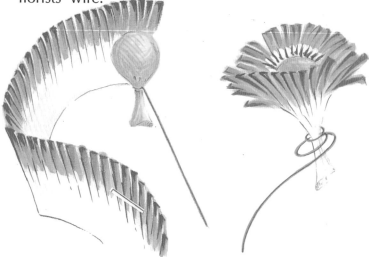

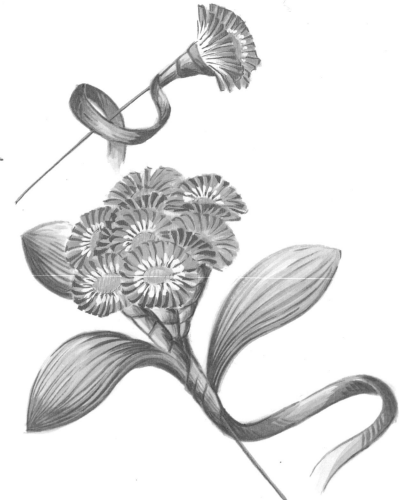

3 Put a little glue on the strip of white crepe paper and roll it neatly round the heart of the flower. Tie with wire, using the long tail to form the stem. Cover the stem with green florists' tape.

4 Make several leaves using double layers of green crepe paper. Place these around the flowers and secure with tape. Make several bunches of flowers and display in a basket filled with reindeer moss, as shown in the photograph.

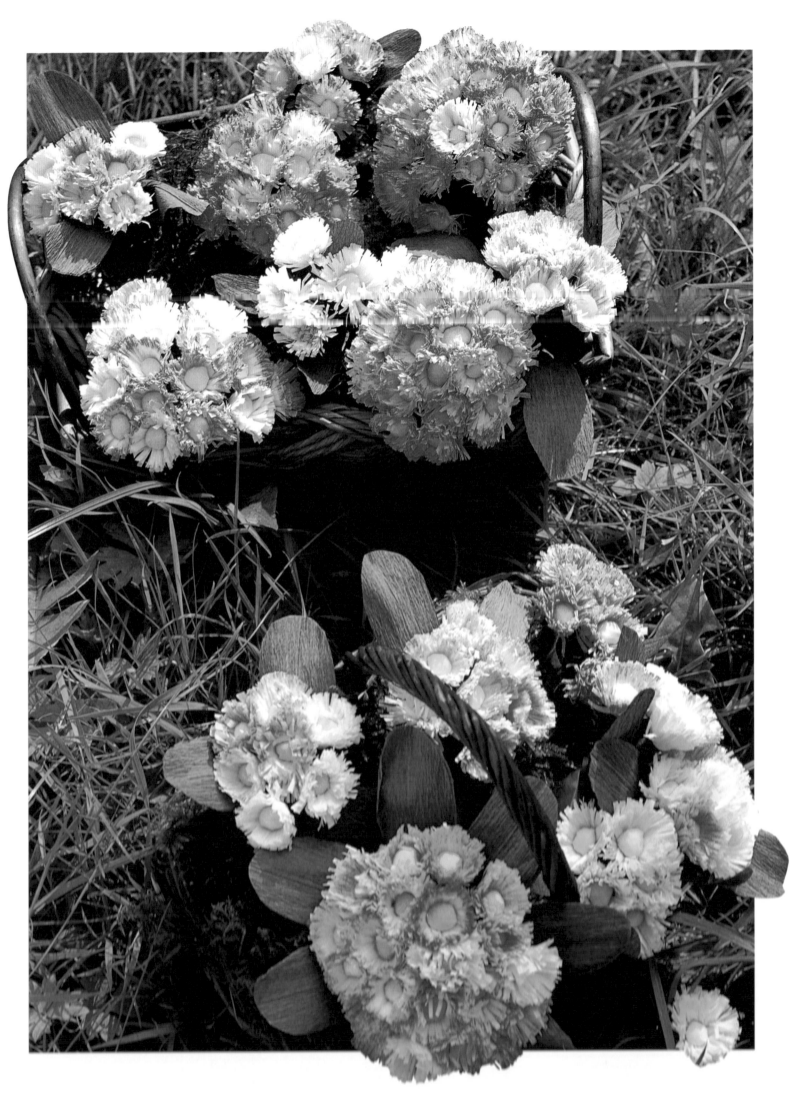

Crocuses

You will need: green and various shades of yellow crepe paper • orange pastel crayon or felt-tip pen • templates (from the front of the book) • scissors • florists' wire • glue • thread • green florists' tape • ruler

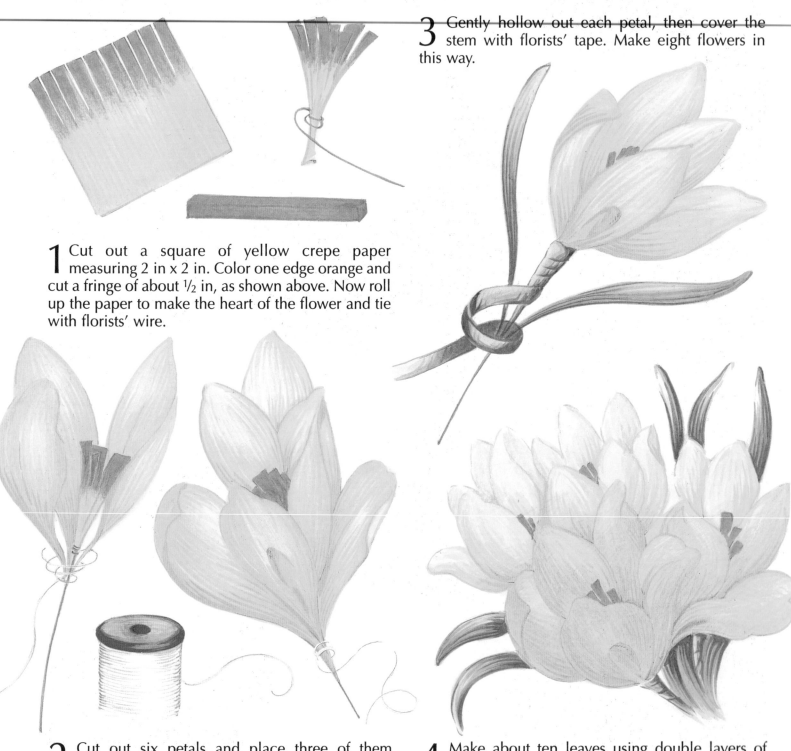

3 Gently hollow out each petal, then cover the stem with florists' tape. Make eight flowers in this way.

1 Cut out a square of yellow crepe paper measuring 2 in x 2 in. Color one edge orange and cut a fringe of about ½ in, as shown above. Now roll up the paper to make the heart of the flower and tie with florists' wire.

2 Cut out six petals and place three of them around the heart of the flower, attaching them with a dab of glue. Now glue the other three petals between the first three and tie with some thread.

4 Make about ten leaves using double layers of green crepe paper. Place one or two leaves around each flower and secure with tape. Finally, gather your flowers into a bouquet.

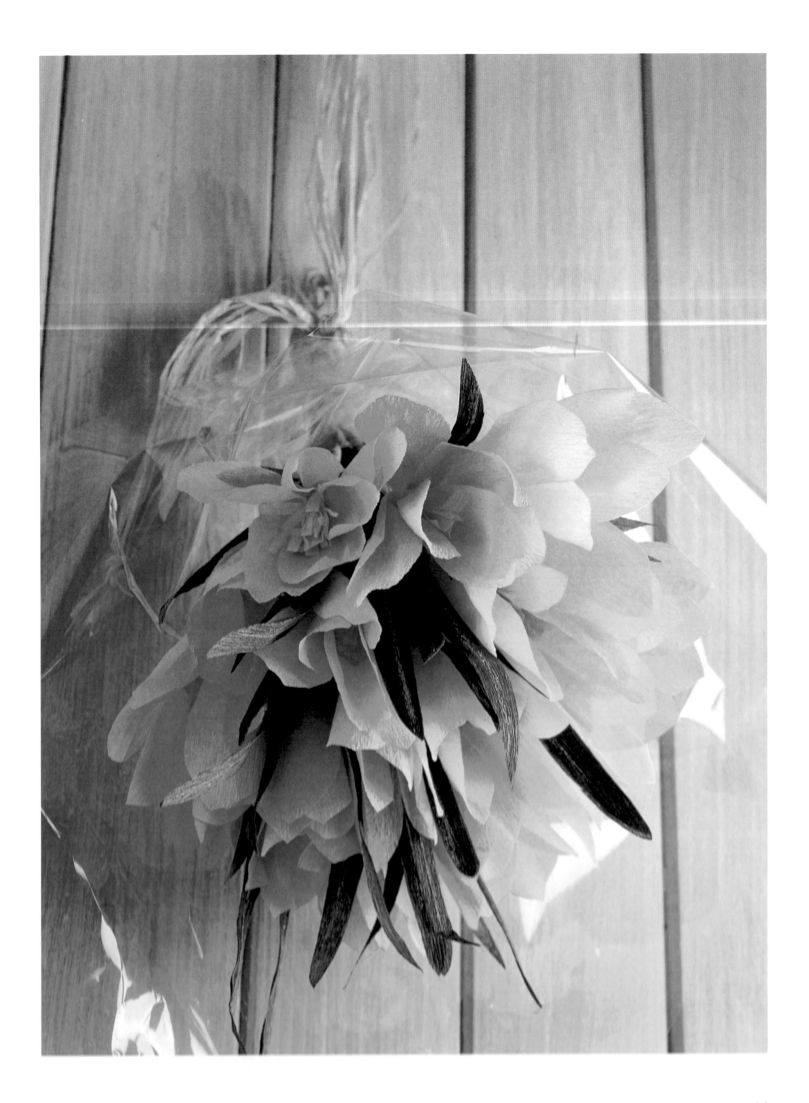

Snowdrops

You will need: white and green crepe paper • green pastel crayon • templates (from the front of the book) • scissors • florists' wire • glue • thread • reindeer moss • florists' tape

Snowdrops are white, but you can make them in different colors if you like.

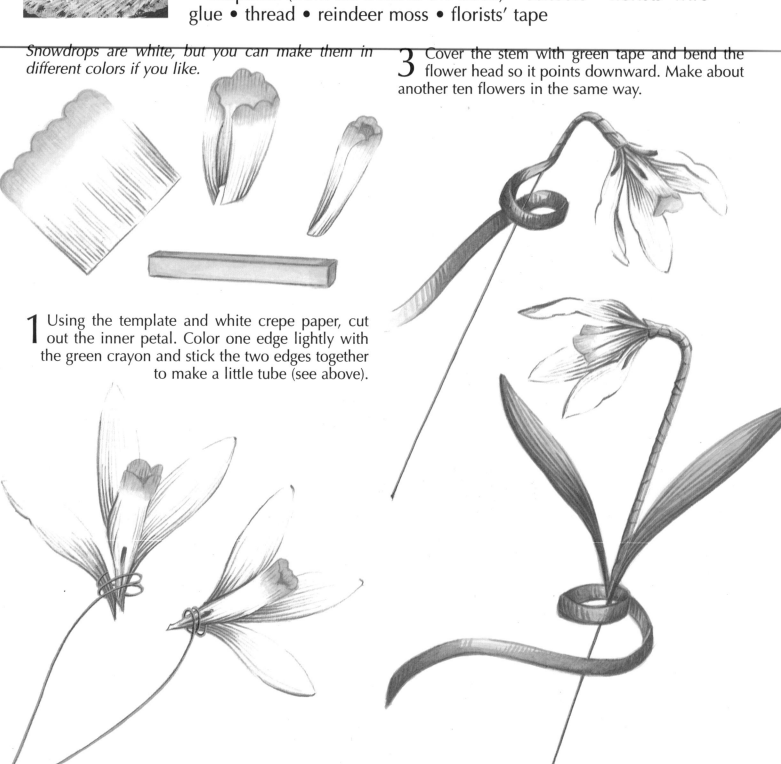

3 Cover the stem with green tape and bend the flower head so it points downward. Make about another ten flowers in the same way.

1 Using the template and white crepe paper, cut out the inner petal. Color one edge lightly with the green crayon and stick the two edges together to make a little tube (see above).

2 Cut out three white outer petals and glue them so they flare out around the inner petal. Bind the bottom with thread and fasten with wire to make a stem.

4 Make two leaves using double layers of green crepe paper. Place these either side of the stem and secure with tape. Stand the snowdrops in reindeer moss to display them.

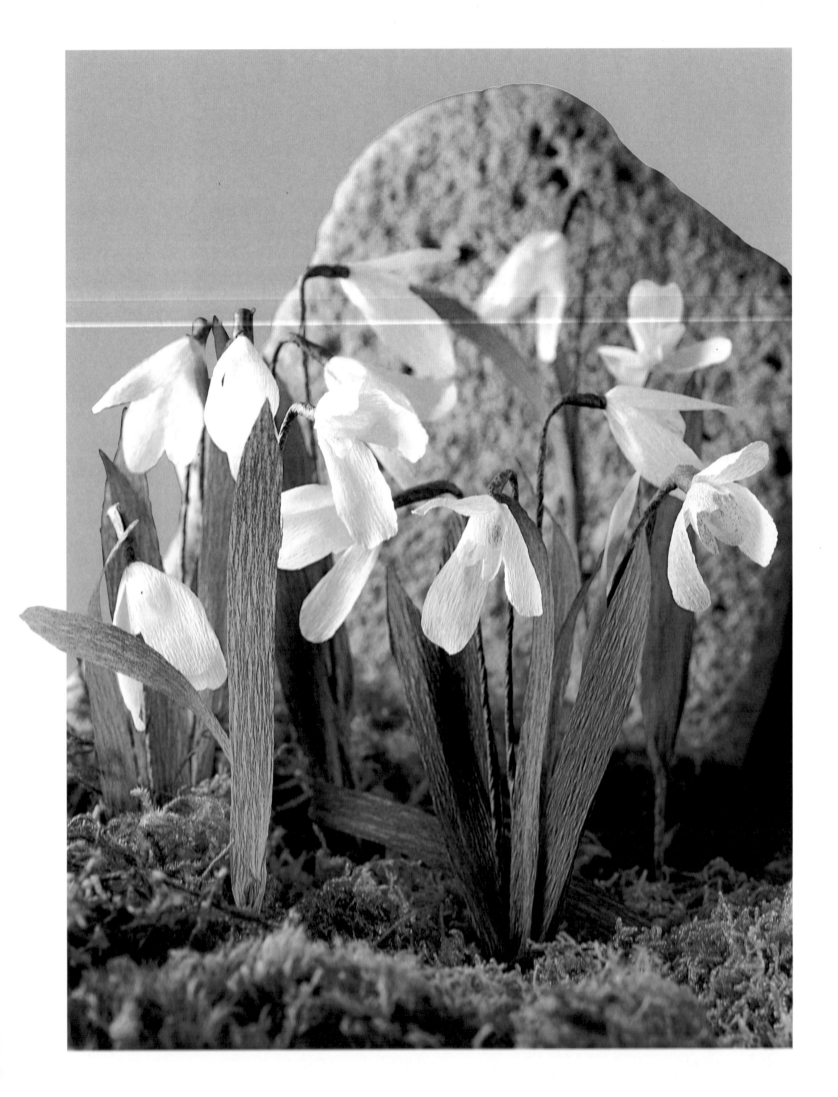

Flower jewelry

You will need: a plain barrette • a narrow hairband • pink, white, yellow and green crepe paper • templates (from the front of the book) • scissors • florists' wire • glue • green florists' tape • ruler

1 First make the flowers. Cut out a strip of yellow crepe paper measuring 5 in x 1 in. Cut a fine fringe along one edge of the strip, roll it up and fasten with wire (see above). This is the heart of the flower.

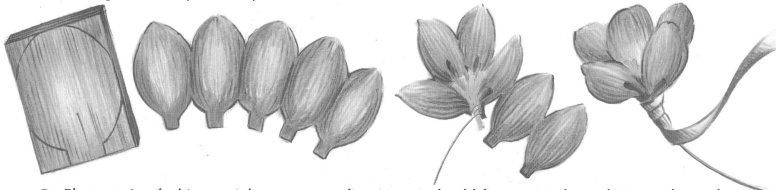

2 Pleat a strip of white or pink crepe paper five times. It should fit your petal template exactly, as shown above. Cut off the four corners of the crepe paper, leaving the edges joined. When you unfold the strip you should have a string of petals. Put a little glue on the heart of the flower and roll the strip around it. Tie with florists' wire and cover about 1½ in of the stem with green tape.

The barrette

The hair band

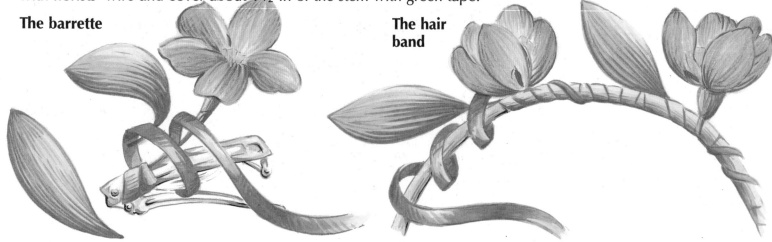

3 Make two leaves using double layers of green crepe paper. Attach one leaf and three flowers to the barrette and fasten with florists' tape. Finish off with the second leaf.

4 Make four more leaves. Starting from the middle of the hair band, intertwine leaves and flowers by winding them around the hair band. Fasten with tape.

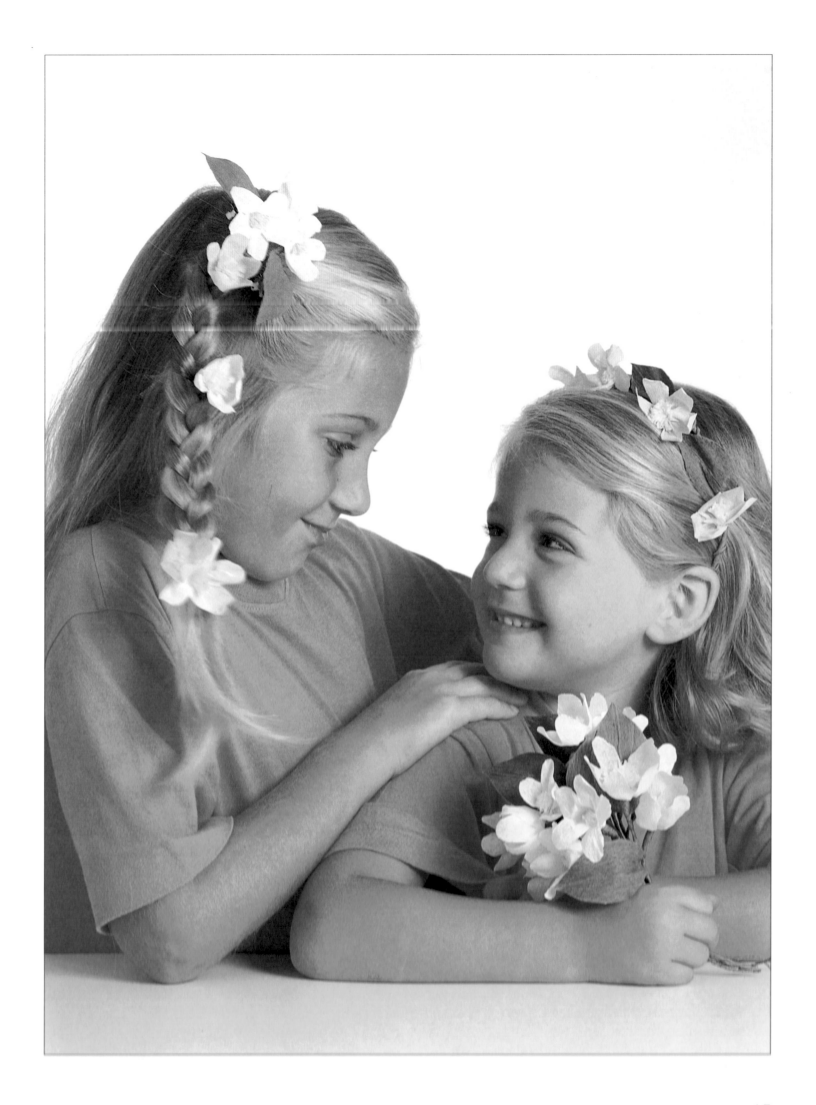

Miniature flowers

You will need: crepe paper in various colors • scissors • templates (from the front of the book) • florists' wire • green florists' tape • ruler • small earthenware flower pots • reindeer moss • colored nylon netting • scented beads or shavings of scented soap

A miniature garden

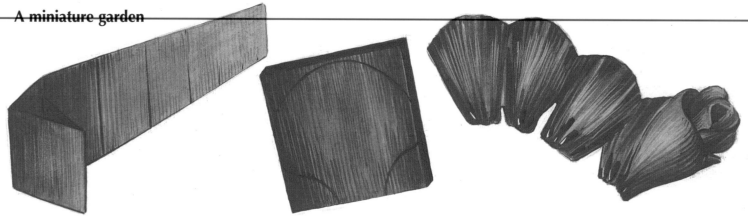

1 Cut out a strip of paper measuring 10 in x 1½ in. Pleat the strip into eight with folds every 1¼ in.

2 Draw around the petal template, as shown. Cut off the four corners of the crepe paper, leaving the edges joined. Now unfold your strip of petals. Hollow out the top of each petal, then roll up the strip to make your flower.

Scented flower bouquet

1 Cut out a piece of netting (3 in x 3 in). Place scented beads or soap shavings in the center and tie with wire. Cover the stem with florists' tape.

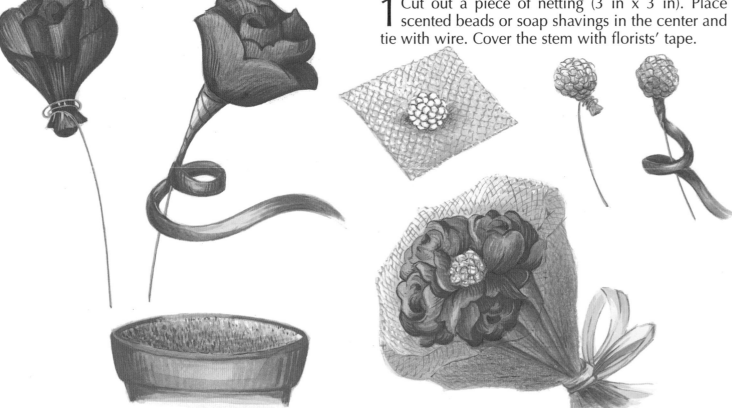

3 Tie the bottom of the petals with wire and cover the stem with tape. Fill the flower pots with reindeer moss and plant several flowers in each.

2 Arrange flowers around this scented ball and wrap them in another piece of nylon netting.

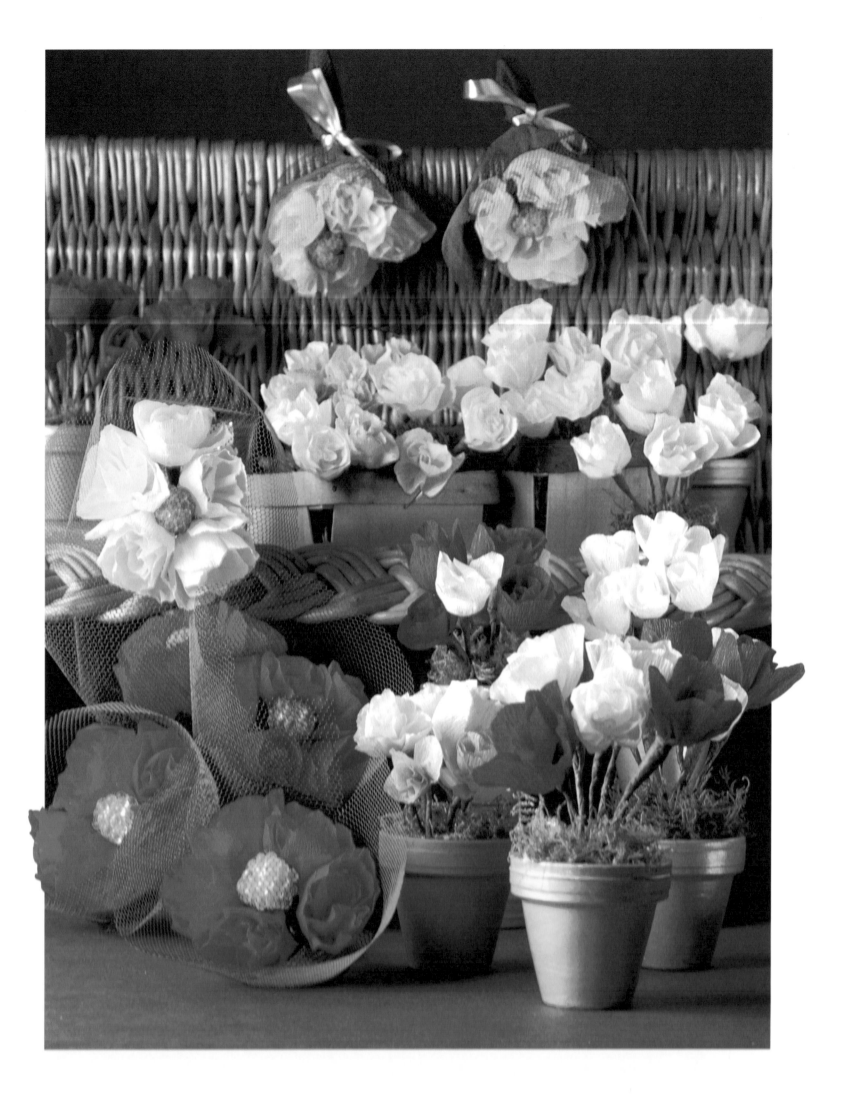

Primroses

You will need: crepe paper in various colors, including green •
yellow pastel crayon • templates (from the back of the book) •
scissors • florists' wire • glue • small earthenware flower pots •
green florists' tape • reindeer moss

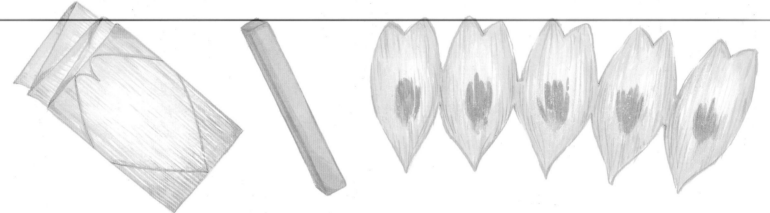

1 Pleat a strip of crepe paper five times. It should fit your petal template exactly, as shown above. Cut off the four corners of the crepe paper, leaving the edges joined. When you unfold the strip you should have a string of petals. Color the center of each one with the yellow crayon.

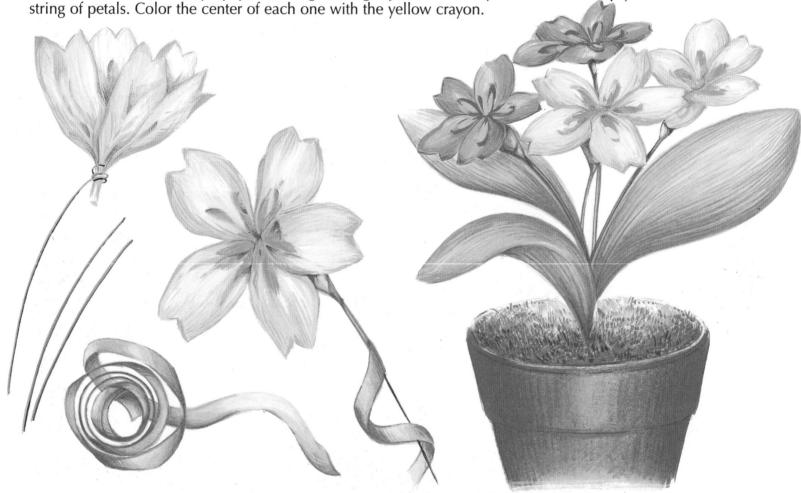

2 Gather the petals together at the base and secure with wire. Separate the petals and gently curve them outwards. Cover the stem with green tape.

3 Make three leaves and arrange these around the flowers. Fill a flower pot with moss and plant the flowers in it.

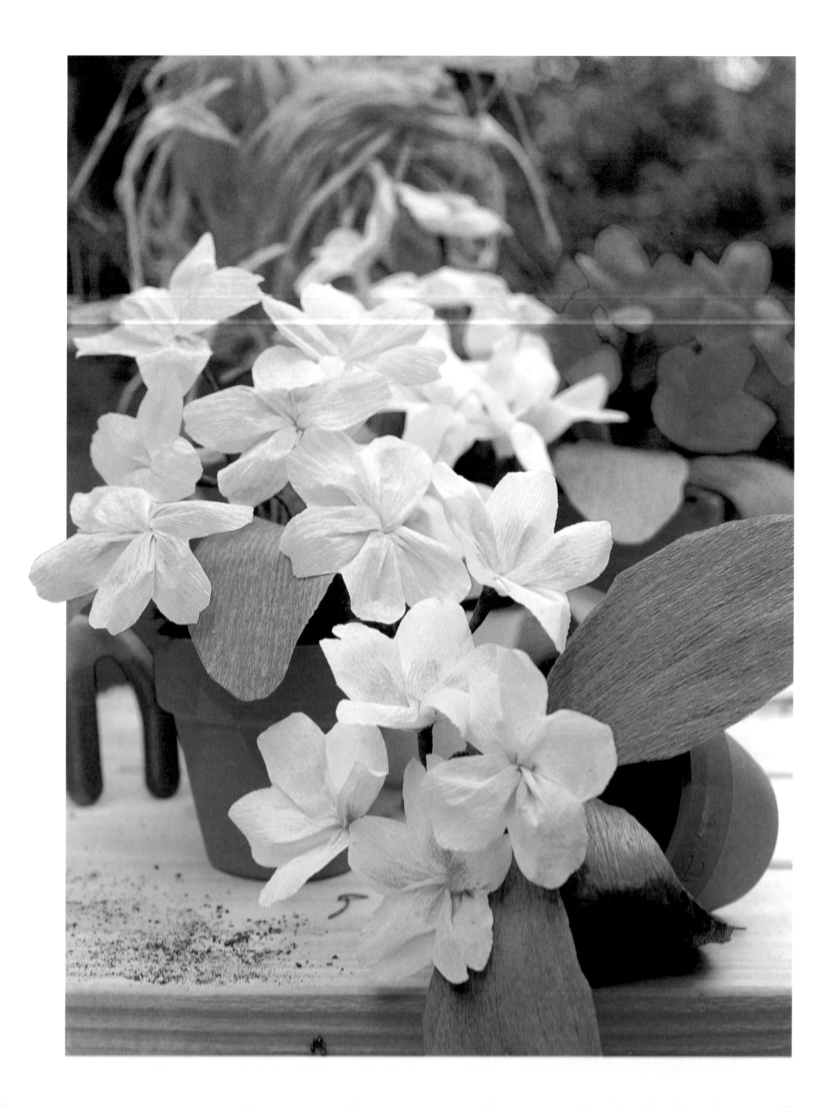

Rosebuds

You will need: crepe paper in green and red (or a color of your choice) • templates (from the back of the book) • scissors • florists' wire • glue • cotton wool • green florists' tape • raffia or ribbon

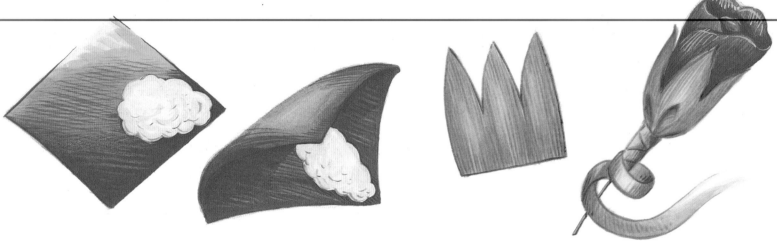

1 Cut out a square of colored crepe paper measuring 2 in x 2 in. Place an egg-shaped piece of cotton wool in one corner, as shown above.

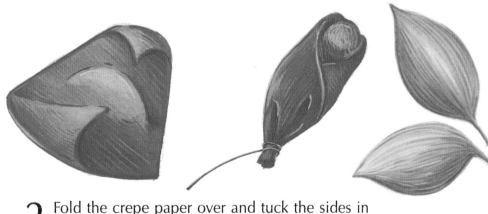

2 Fold the crepe paper over and tuck the sides in around the cotton wool. Tie with florists' wire. This makes the heart of the flower.

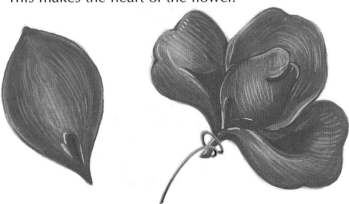

3 Cut out three petals. Hollow them out and turn them inwards. Arrange the three petals around the heart. Apply glue and secure with wire.

4 Using green crepe paper, cut out the sepals and place around the rosebud. Apply glue and tie with wire. Cover the stem with florists' tape. Make seven to nine flowers in the same way.

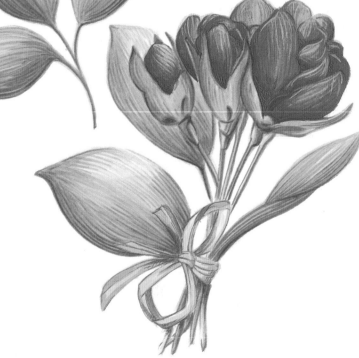

5 Make three leaves. Gather the leaves and flowers into a bunch and tie with raffia or ribbon.

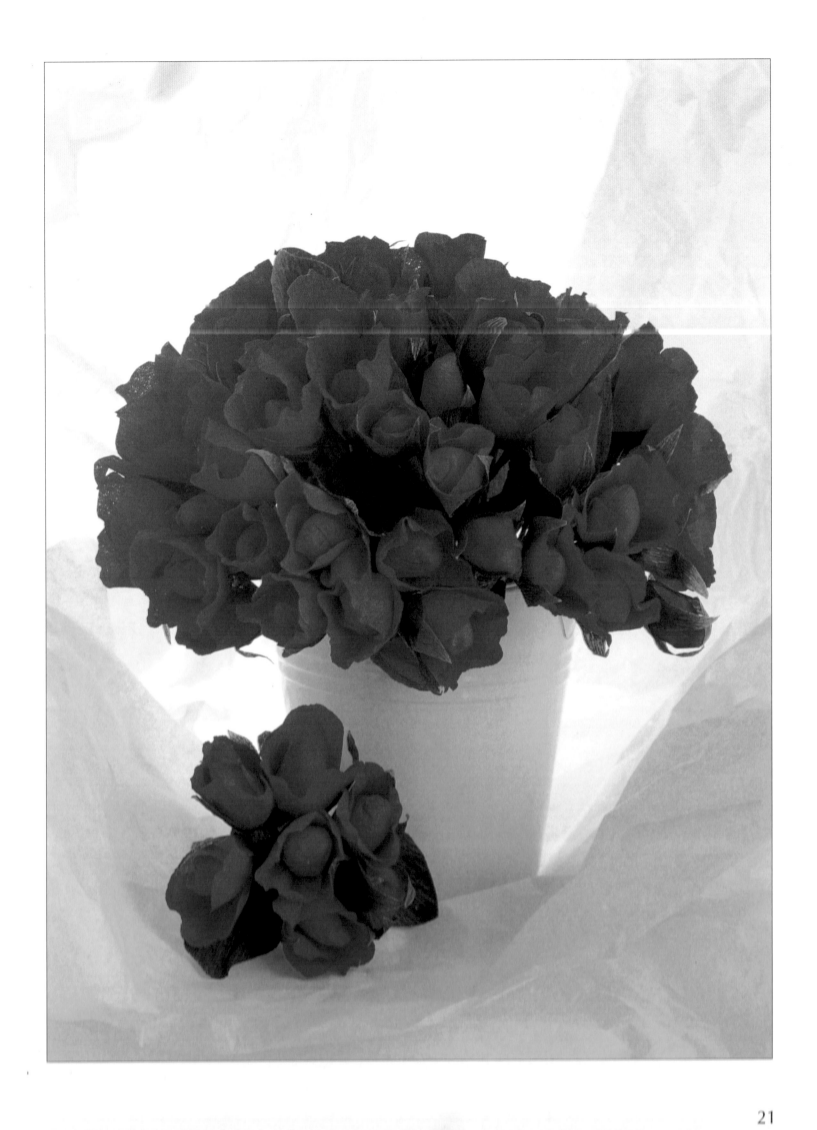

Poppies

You will need: yellow, orange and green crepe paper • black felt-tip pen • cotton wool • wire stem at least 10 in long • glue • templates (from the back of the book) • scissors • thread • green florists' tape • ruler

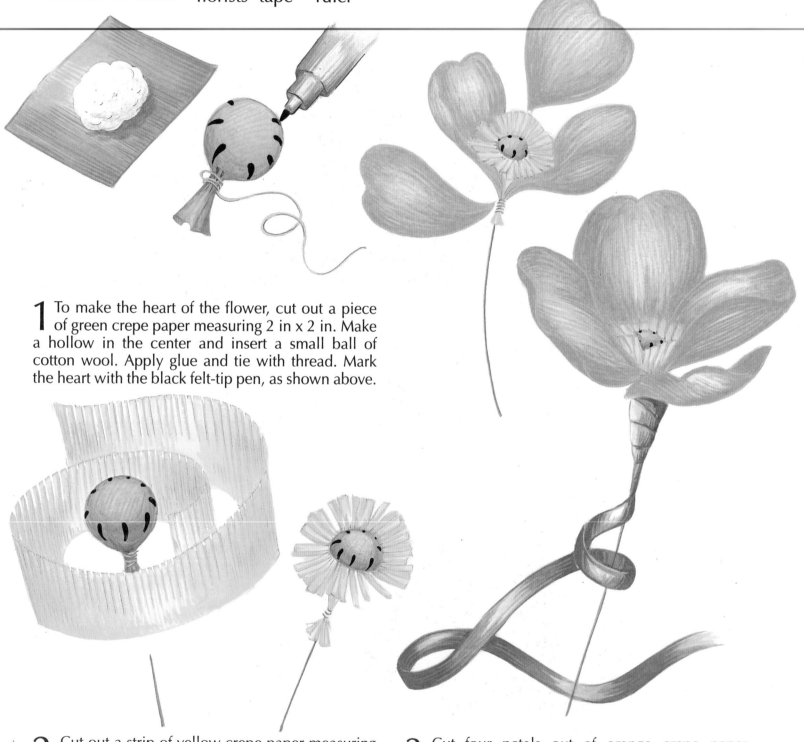

1 To make the heart of the flower, cut out a piece of green crepe paper measuring 2 in x 2 in. Make a hollow in the center and insert a small ball of cotton wool. Apply glue and tie with thread. Mark the heart with the black felt-tip pen, as shown above.

2 Cut out a strip of yellow crepe paper measuring 8 in x 1¼ in. Cut a fringe about ½ in deep along the length of one edge. Apply glue along the other edge and roll it around the heart of the flower. Tie with thread and slide in a metal stem.

3 Cut four petals out of orange crepe paper. Gently hollow out each one and glue them around the heart of the flower. Secure with thread, then cover the stem with florists' tape. Make about twelve of these flowers.

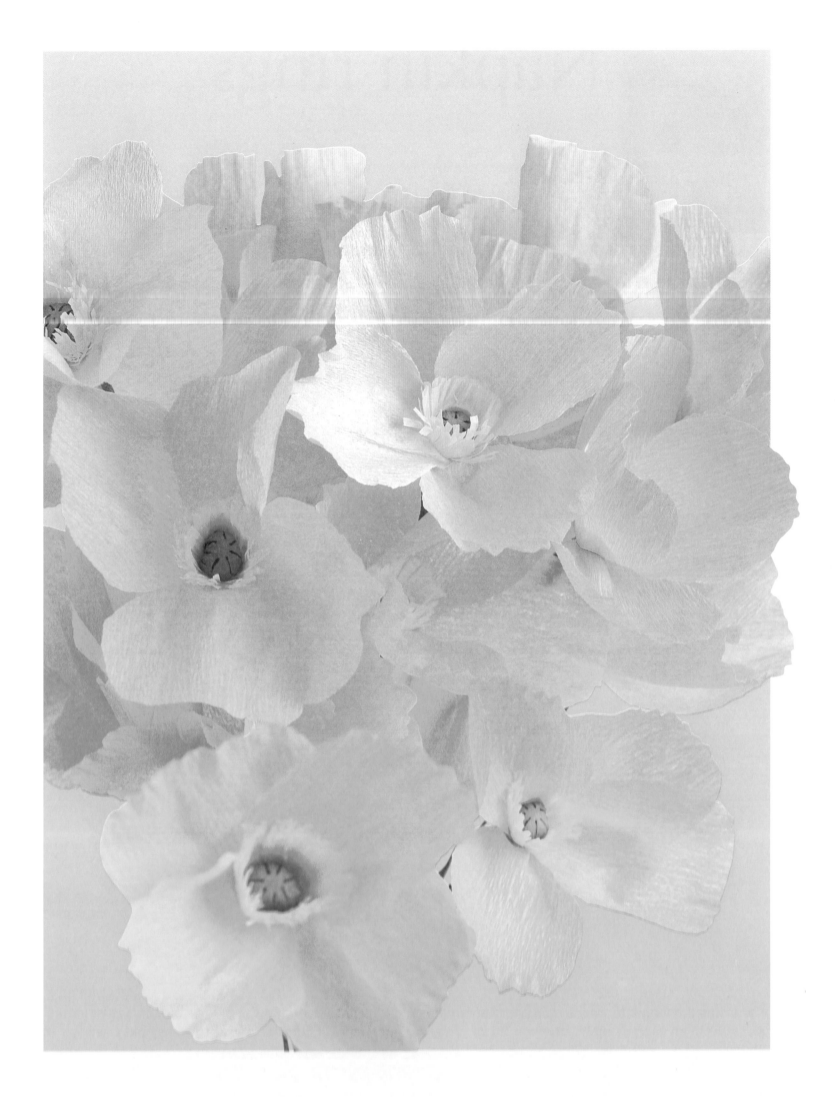

Napkin rings

You will need: cardboard cylinder about 2 in in diameter and height (ask an adult to help you cut this) • colored crepe paper • yellow crayon or felt-tip pen • natural or colored raffia • glue • template (from the back of the book) • scissors • stapler

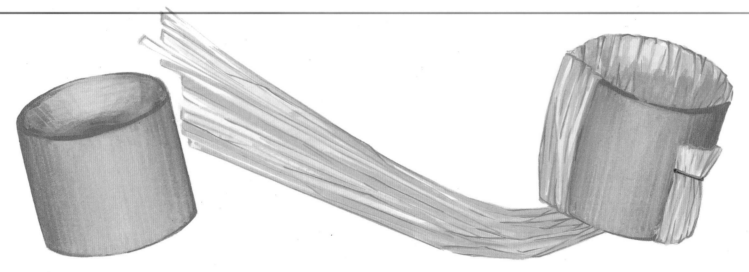

1 Choose six or seven fine long strands of raffia. Staple the strands to the inside of the cardboard ring and wind them all around to cover it. Then staple the ends.

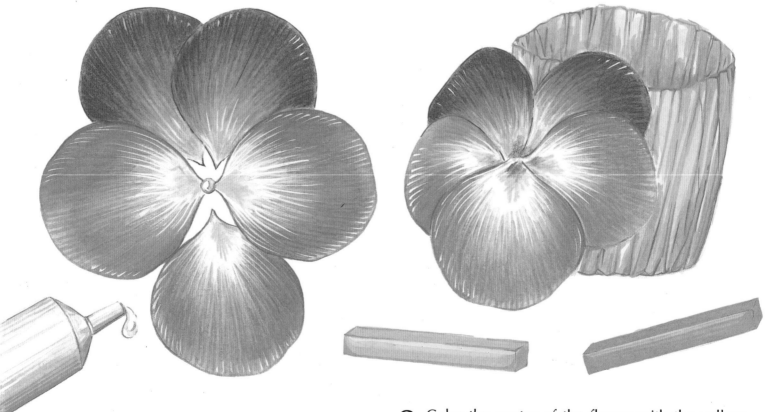

2 Using the template, cut out five pansy petals and glue them to each other, one by one, as shown above.

3 Color the center of the flower with the yellow crayon or felt-tip and draw a few lines radiating outwards. Glue the pansy to the napkin ring so it hides the last staple.

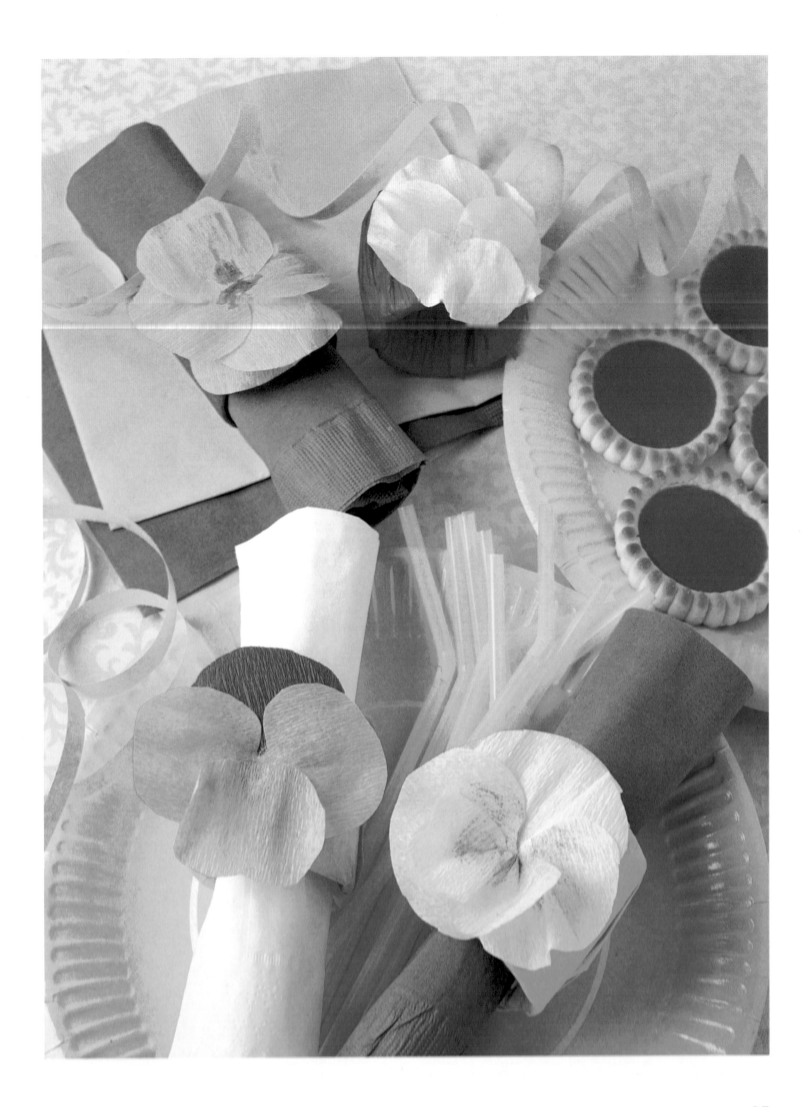

Four-leaved clover

You will need: green crepe paper • florists' wire • glue • template (from the back of the book) • scissors • green florists' tape

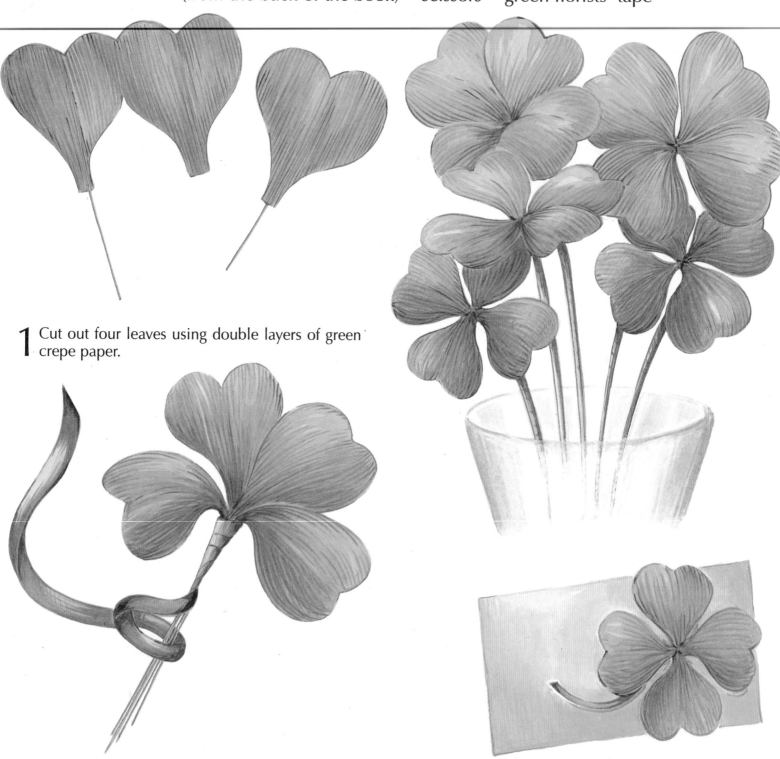

1 Cut out four leaves using double layers of green crepe paper.

2 Make the clover by gathering together the four wires and winding them into a single stem. Cover the stem with tape.

3 Use your clovers to make various attractive gifts, such as the good luck cards shown in the photograph.

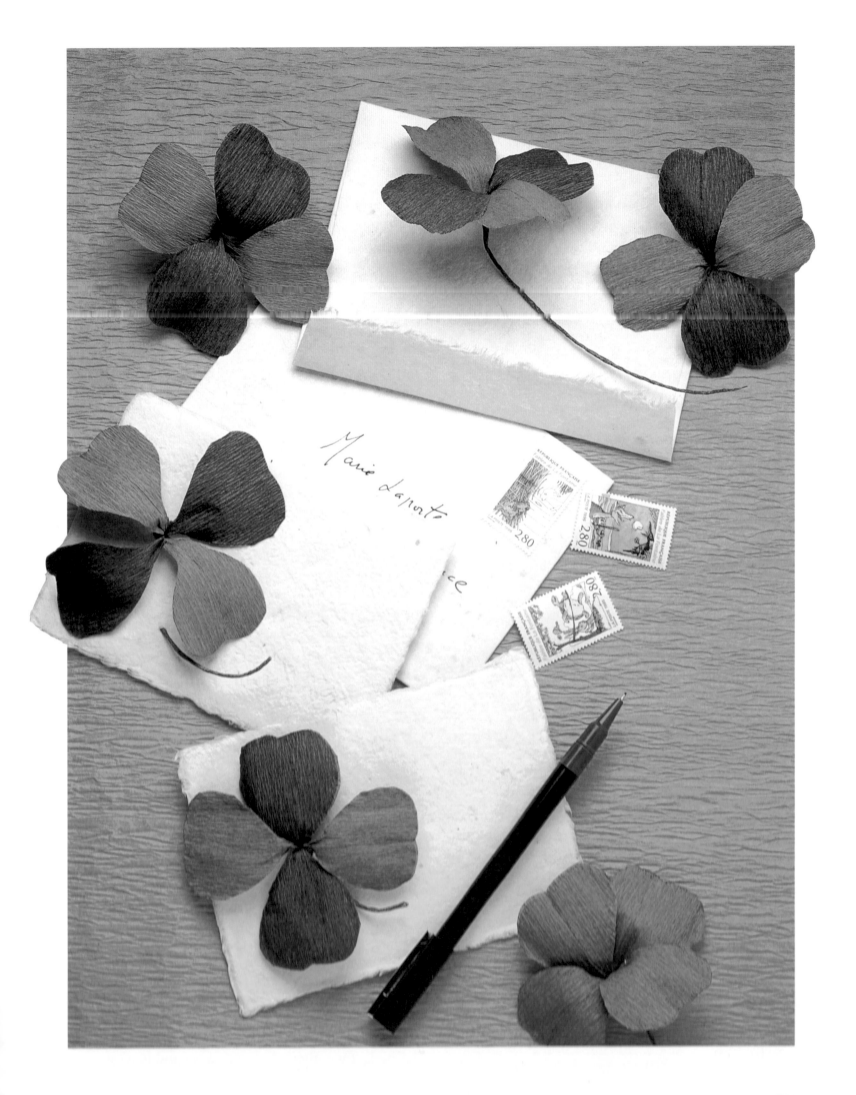

Bellflowers

You will need: crepe paper in green, yellow, white, pink and various shades of blue • florists' wire • glue • templates (from the back of the book) • scissors • green florists' tape • electricians' wire • ruler

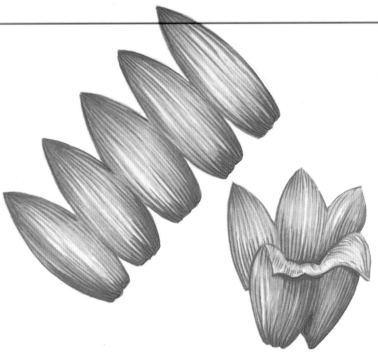

3 Cut out three buds and hollow them out. Roll them up and tie with wire. Cover the top 1½ in of the stem with tape, then make several leaves.

1 Using the template, cut out several flower shapes in one color of crepe paper. Turn out the point of each petal and hollow out the centers.

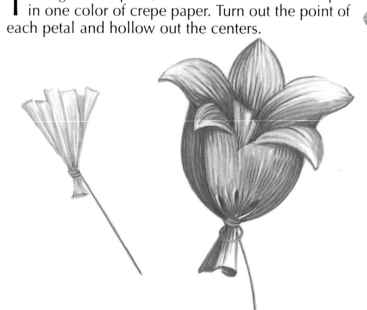

2 To make the heart of the flower, cut out a strip of yellow crepe paper measuring 1 in x ½ in. Make two snips in one edge and gather the other edge securely with wire. Apply glue and secure in the middle of each bell using the wire attached to the heart. Cover the stem with tape to a depth of about 1½ in.

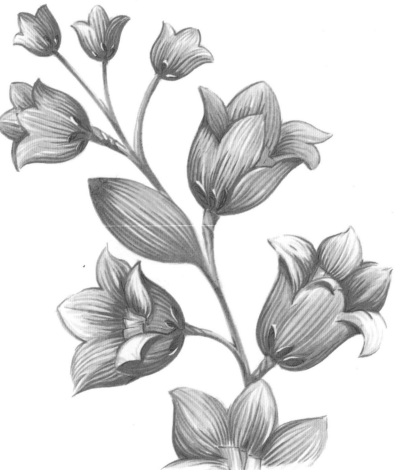

4 Using the electricians' wire and florists' tape, put together the bellflower branch. Begin with the buds, then alternate the flowers and leaves.

28

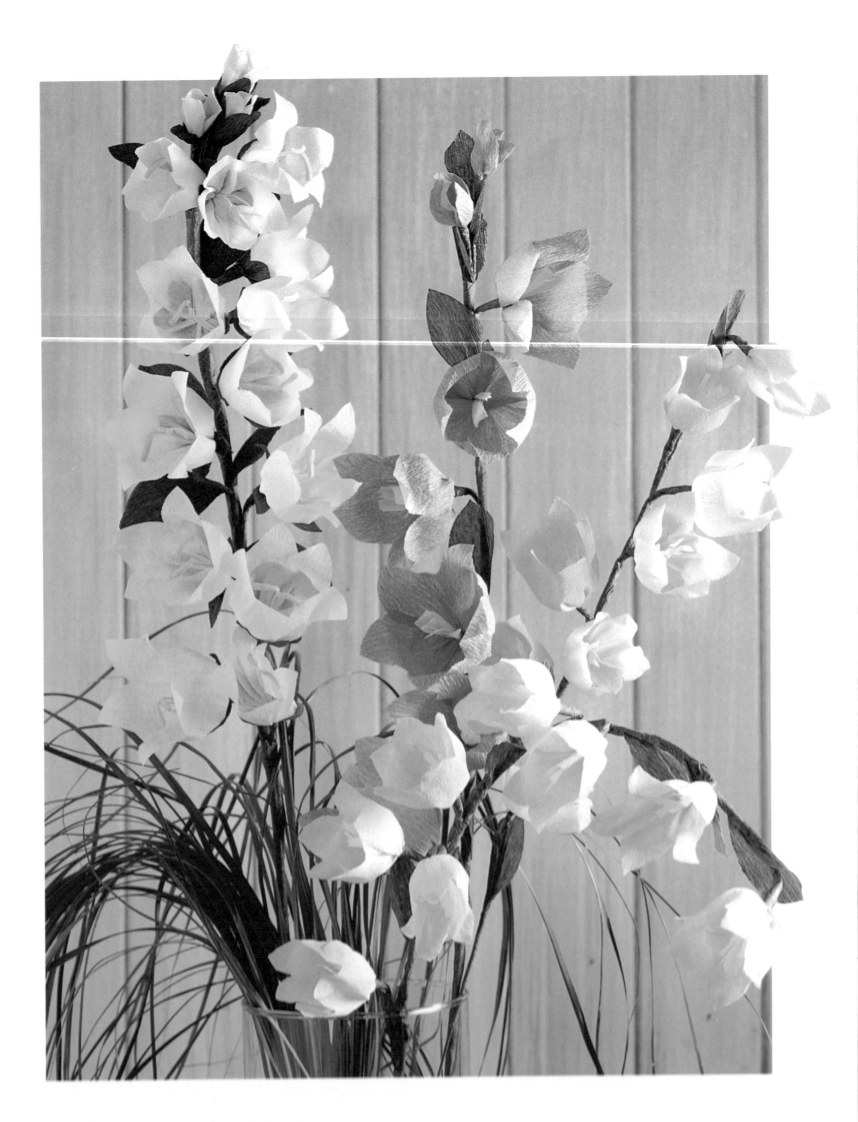

Templates

Primroses p. 18

Rosebuds p. 20

Poppies p. 22

x 5

petal

x 3

petal

x 4

petal

cut out two
each time

leaf

sepals

leaf

1¼ in x 8 in

fringed strip